CELESTIAL YOSEMITE

KRISTAL LEONARD

YOSEMITE CONSERVANCY
YOSEMITE NATIONAL PARK

Near Foresta, a small community of in-holdings within Yosemite National Park, a waxing crescent moon in mid-July sets over a mosaic of burned and unburned trees, displaying the impact of wildfire.

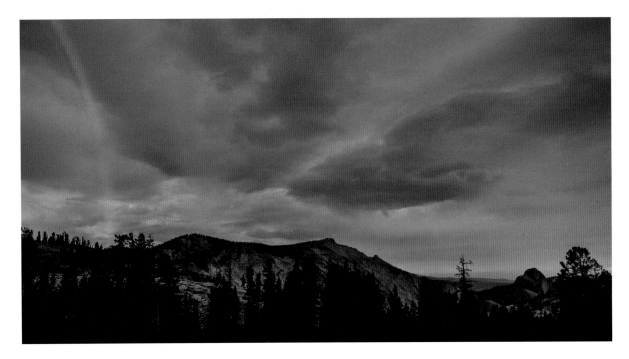

A vibrant rainbow arches steeply in
the southeastern sky as the colors of
a midsummer sunset fade behind Half
Dome in this view from Olmsted Point,
along Tioga Road.

On a cold evening in El Capitan
Meadow, a young crescent moon
descends through the rising mist as
Venus begins to disappear behind
Lower Cathedral Rock.

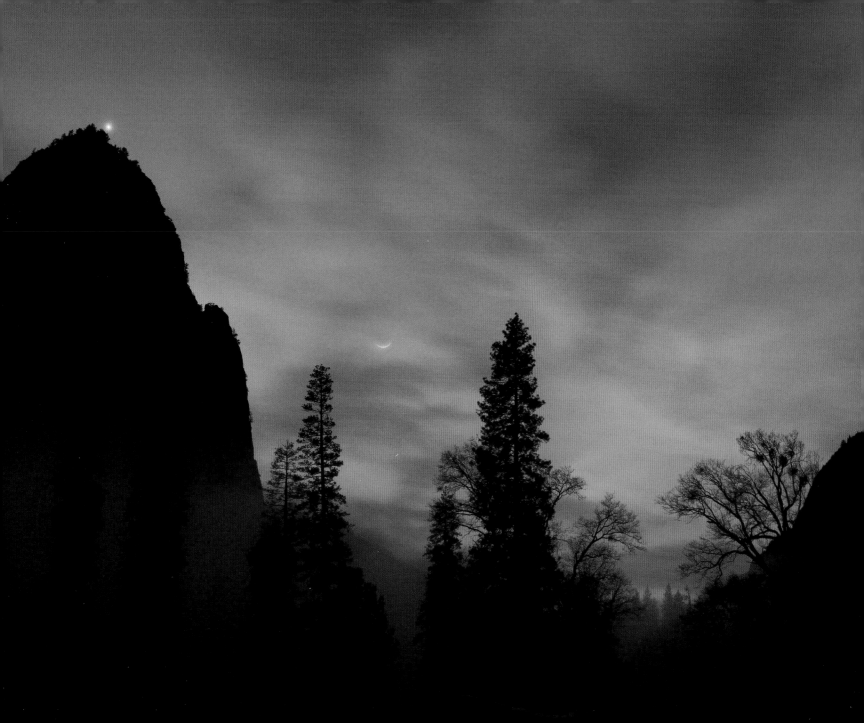

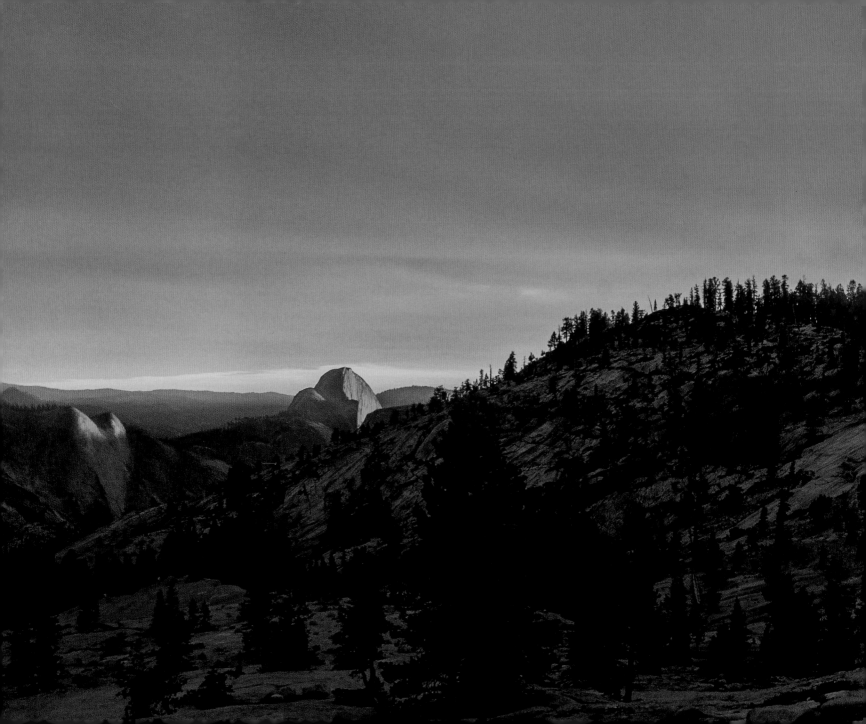

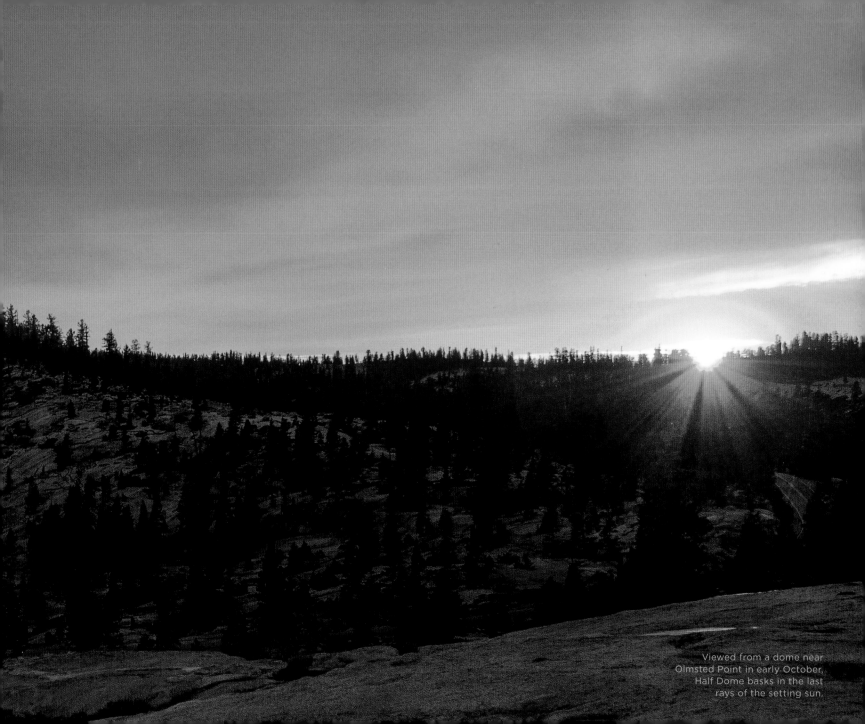

Viewed from a dome near Olmsted Point in early October, Half Dome basks in the last rays of the setting sun.

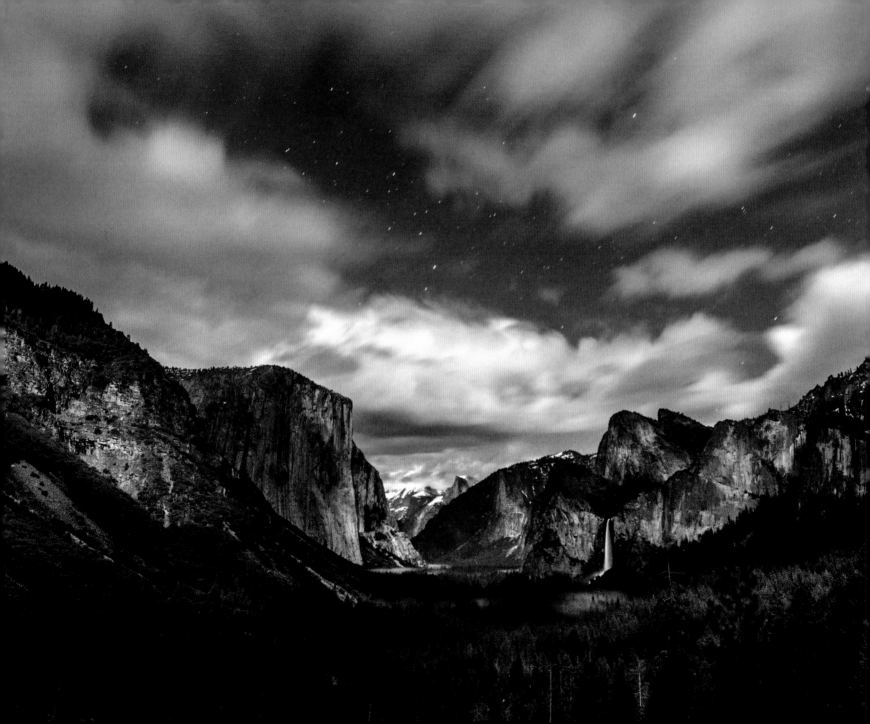

The light from a waxing gibbous moon, combined with a sixty-second exposure, creates a bright nighttime scene of clouds sweeping over Yosemite Valley, as seen from Tunnel View on the spring equinox.

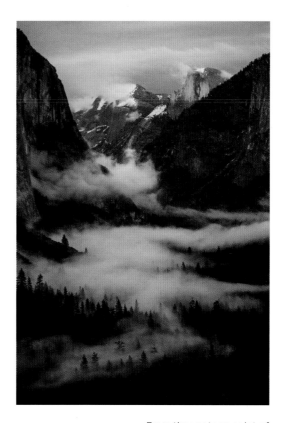

From the vantage point of Tunnel View, fog flows down the floor of Yosemite Valley as sunset illuminates Half Dome and Clouds Rest.

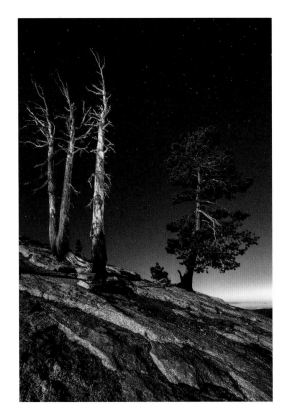

Near the summit of Sentinel Dome, north of Glacier Point Road, twilight and a full moon illuminate a thriving conifer in the company of three snags.

After sunset on a stormy summer evening, Half Dome and the high country capture the fading light.

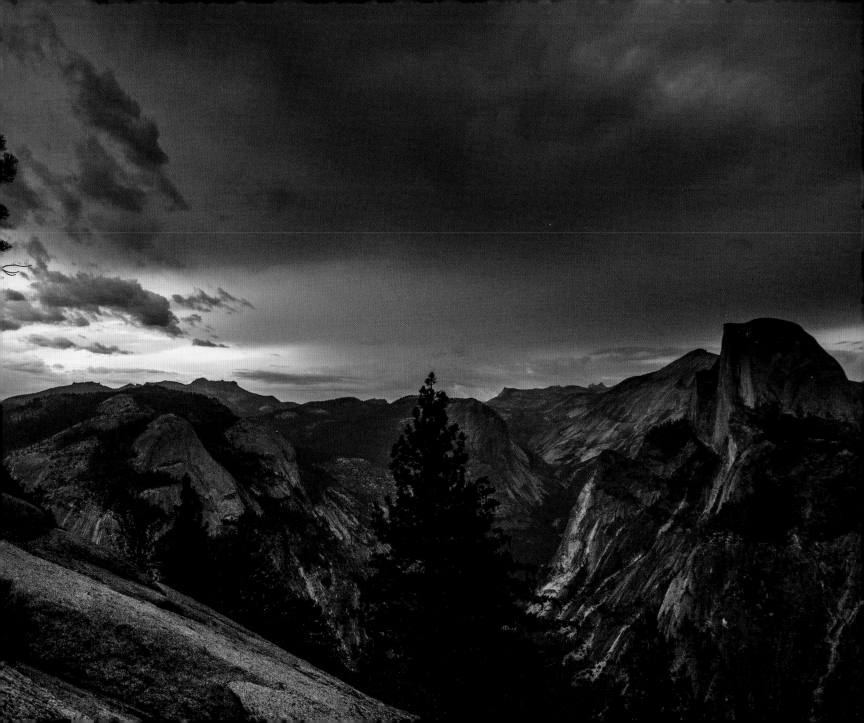

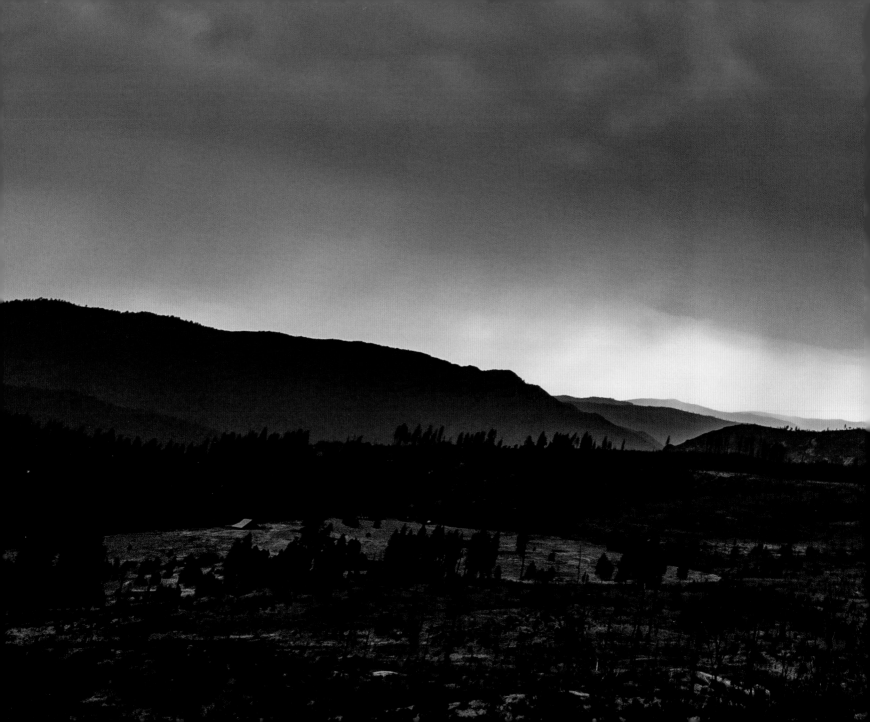

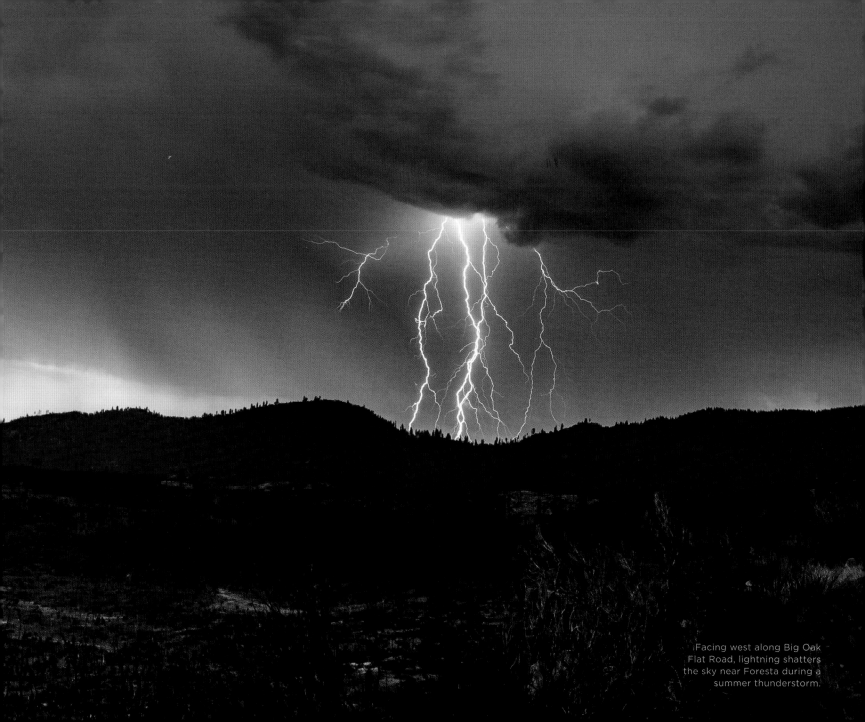

Facing west along Big Oak Flat Road, lightning shatters the sky near Foresta during a summer thunderstorm.

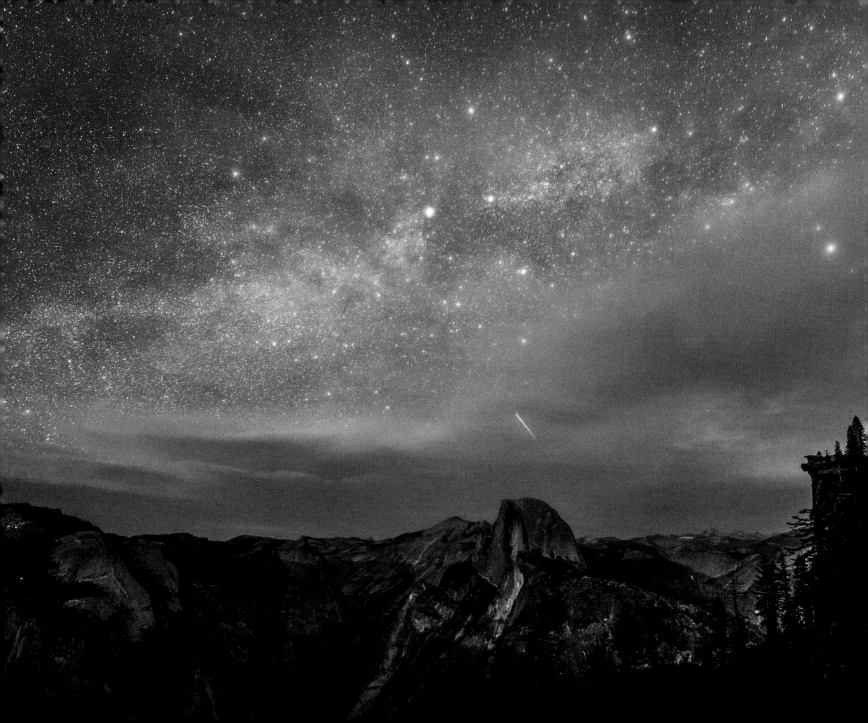

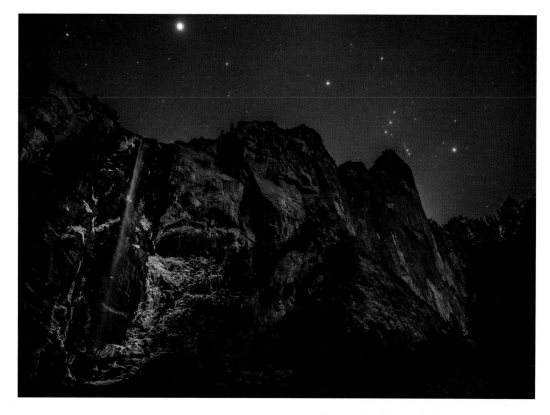

On a cold night in early February, Jupiter sails almost directly above Bridalveil Fall as Orion, a winter constellation in the northern hemisphere, appears over Leaning Tower to the right.

From a spot on Four Mile Trail near Glacier Point, the Milky Way, our galaxy as seen edge on, from within, spans the sky over Tenaya Canyon and Half Dome on the eve of the summer solstice.

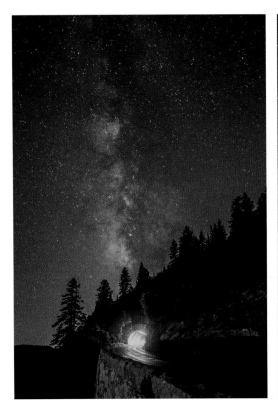

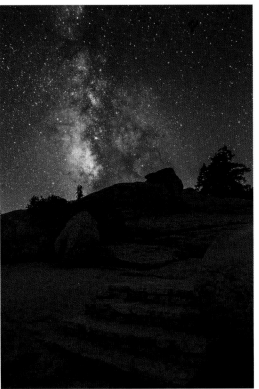

The Milky Way stands tall in the west in a mid-August sky. Beneath it, a fiery orb of golden light marks a tunnel entrance along Big Oak Flat Road.

Stone stairs rise to meet the Milky Way over Glacier Point. Nearly every star seen at night is part of this galaxy.

Airglow fills the arc of the Milky Way in this summer nightscape over the historic Meyer barns, situated in Big Meadow, on the north edge of Foresta. Airglow is light in the high atmosphere created as solar radiation causes various photochemical reactions of gases.

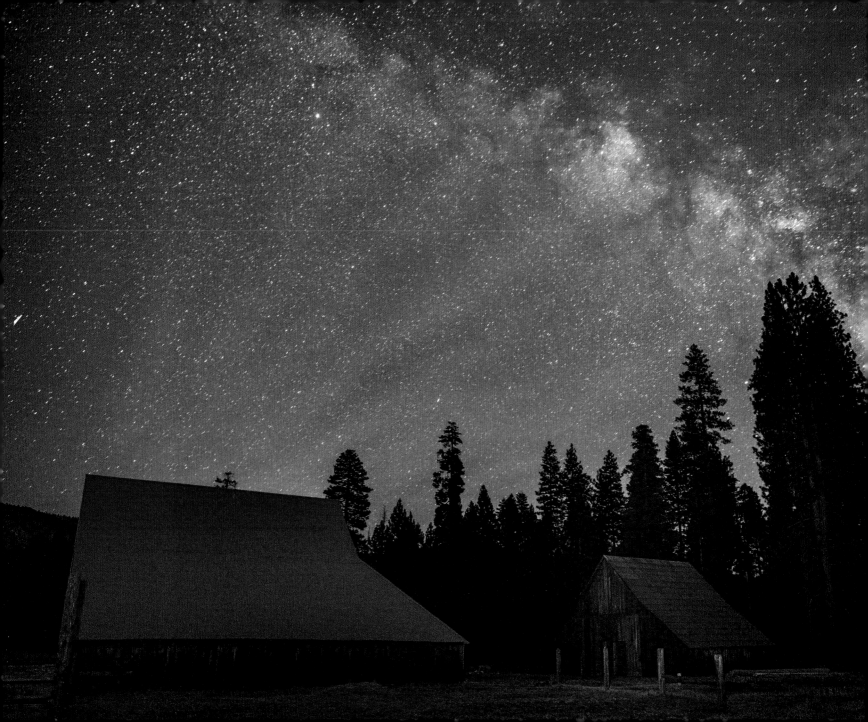

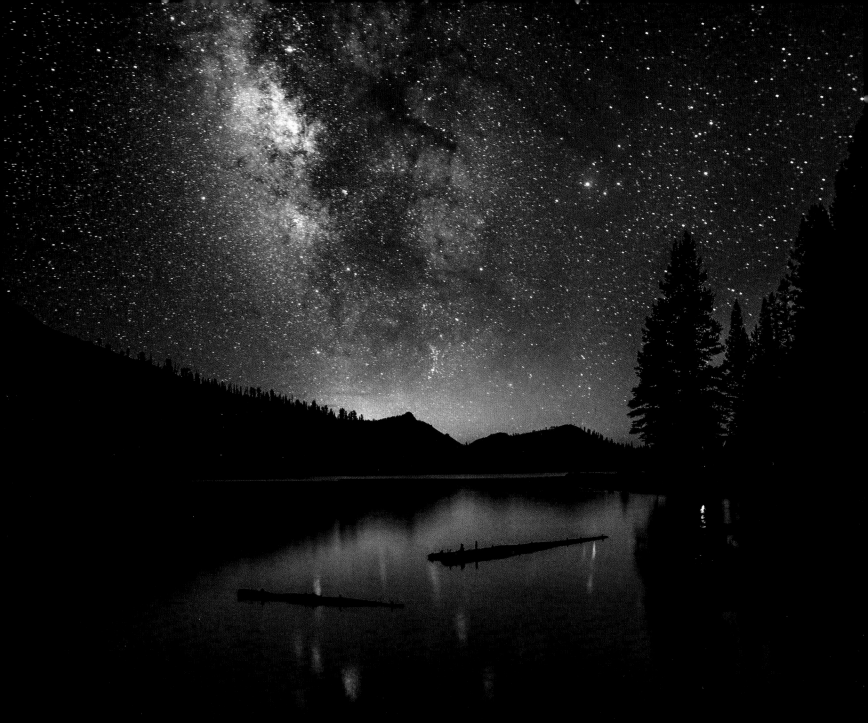

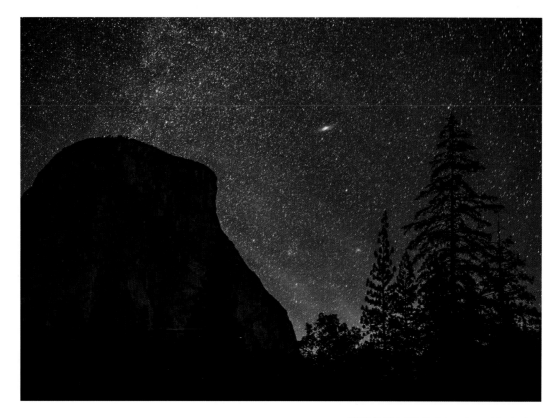

High in the atmosphere, greenish airglow ripples across the night sky behind El Capitan. To the right and lying much farther away, the Andromeda Galaxy, one of the Milky Way Galaxy's closest companions, gleams brightly across a distance of 2.5 million light-years.

On a tranquil August night, the Milky Way extends across the western sky over Tenaya Lake as light pollution from California's Central Valley brightens the horizon below.

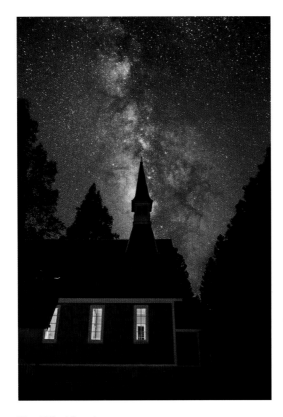

The Milky Way rises over
Yosemite Chapel in late
summer. The chapel, built in
1879, is the oldest structure
in Yosemite Valley.

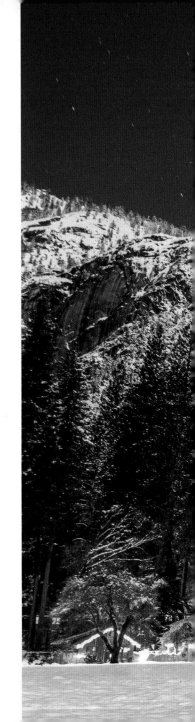

Holiday lights adorn houses
alongside Ahwahnee Meadow,
their colorful glow offering
a warm contrast to Yosemite
Valley's sheer granite walls and
the vast reaches of space beyond.

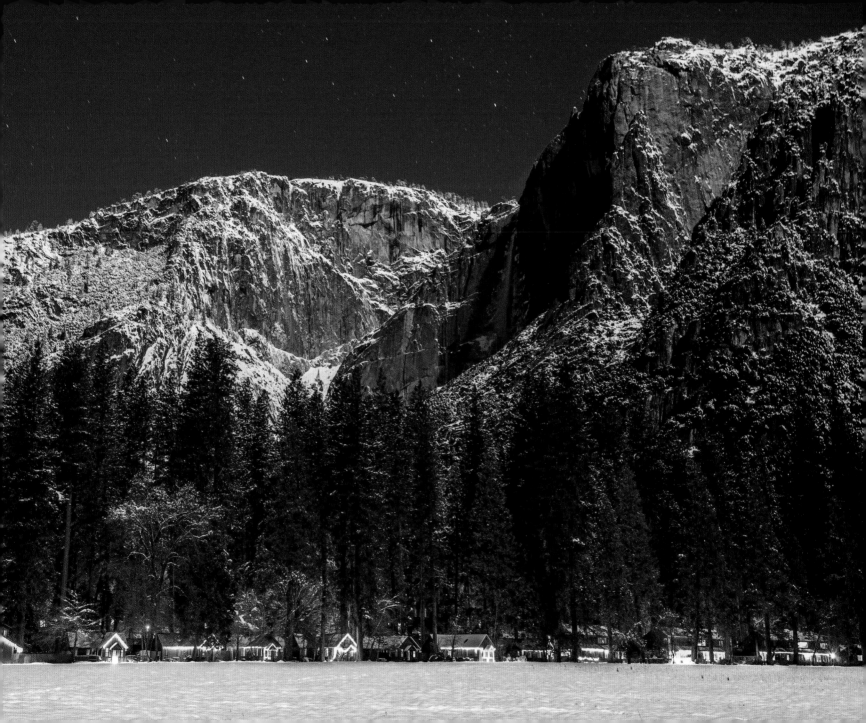

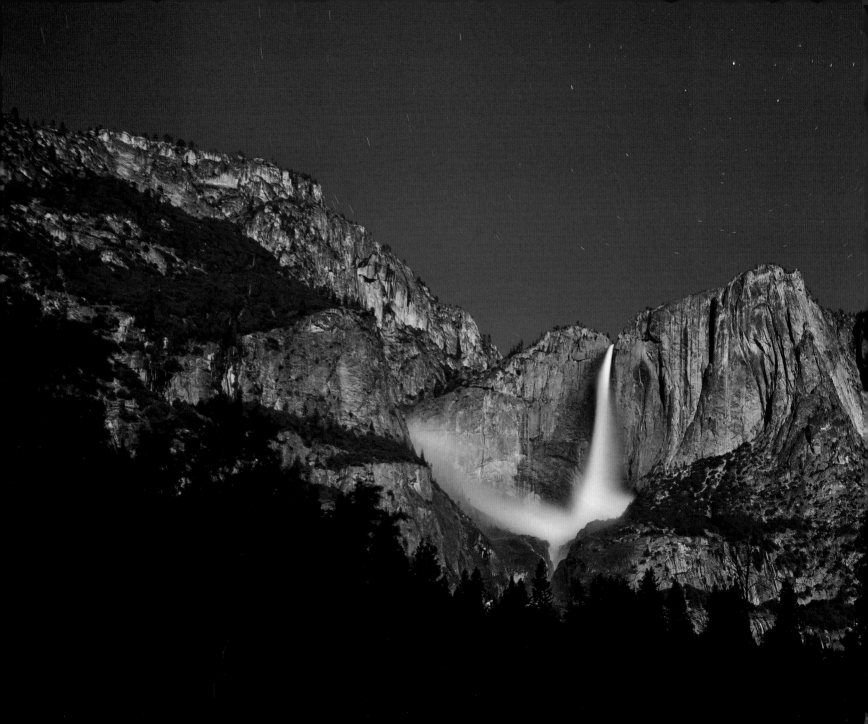

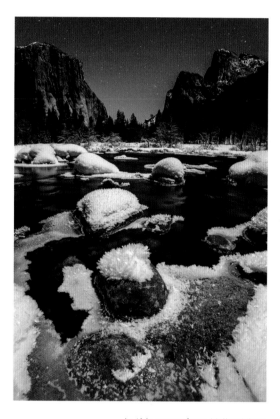

When the moon is full,
or nearly so, during late
spring and early summer,
sometimes conditions are
just right for capturing a
moonbow at Upper Yosemite
Fall as light reflected by the
moon strikes the waterfall's
spray and mist. This June
moonbow is the result of a
thirty-second exposure.

In this scene from Valley View,
at the west end of Yosemite
Valley, illumination from a first-
quarter moon highlights ice,
snow, and well-developed frost
crystals along the Merced River.

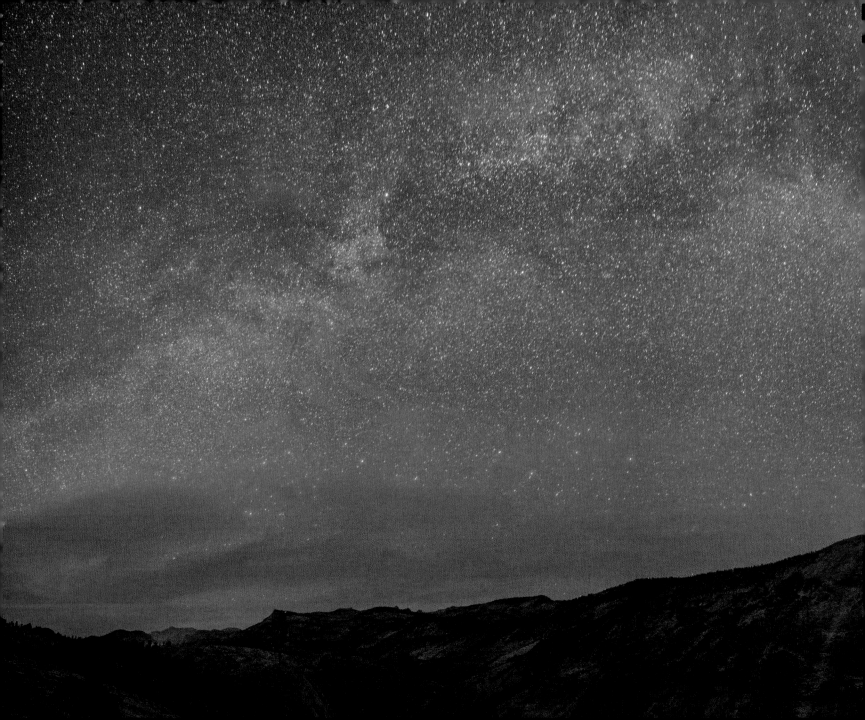

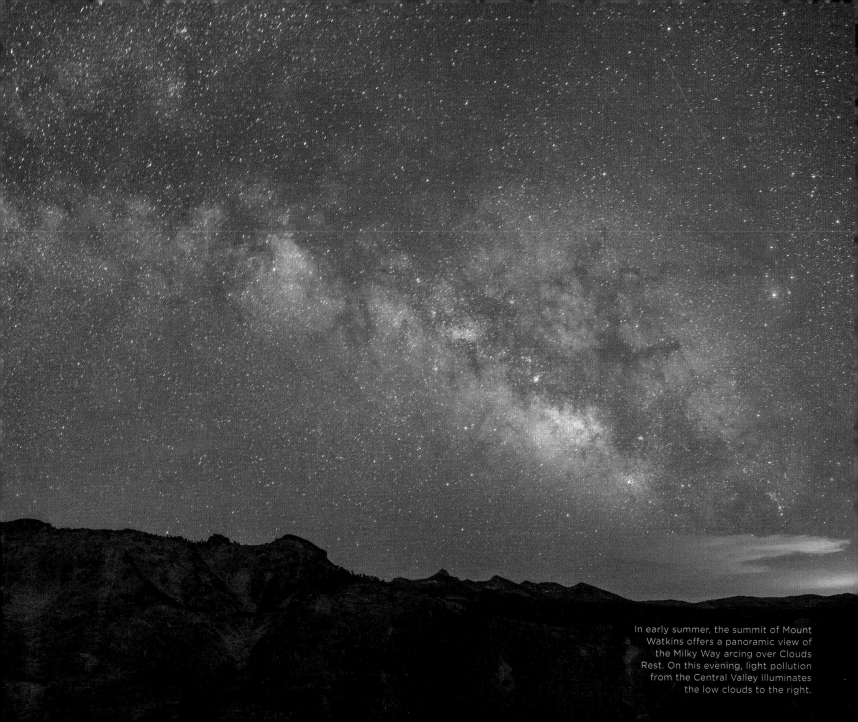

In early summer, the summit of Mount Watkins offers a panoramic view of the Milky Way arcing over Clouds Rest. On this evening, light pollution from the Central Valley illuminates the low clouds to the right.

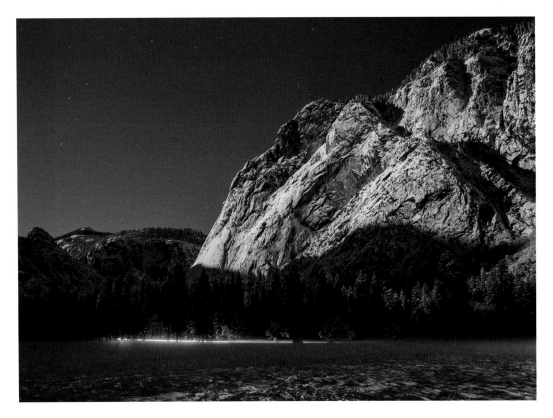

A car's headlights illuminate Ahwahnee Meadow as a snow-covered Glacier Point basks in the moonlight in this sixty-second exposure.

The warmly glowing lights of Yosemite Valley lie nestled within the Valley's granite walls. A full moon casts its silver light on the scene, captured from Yosemite Falls Trail.

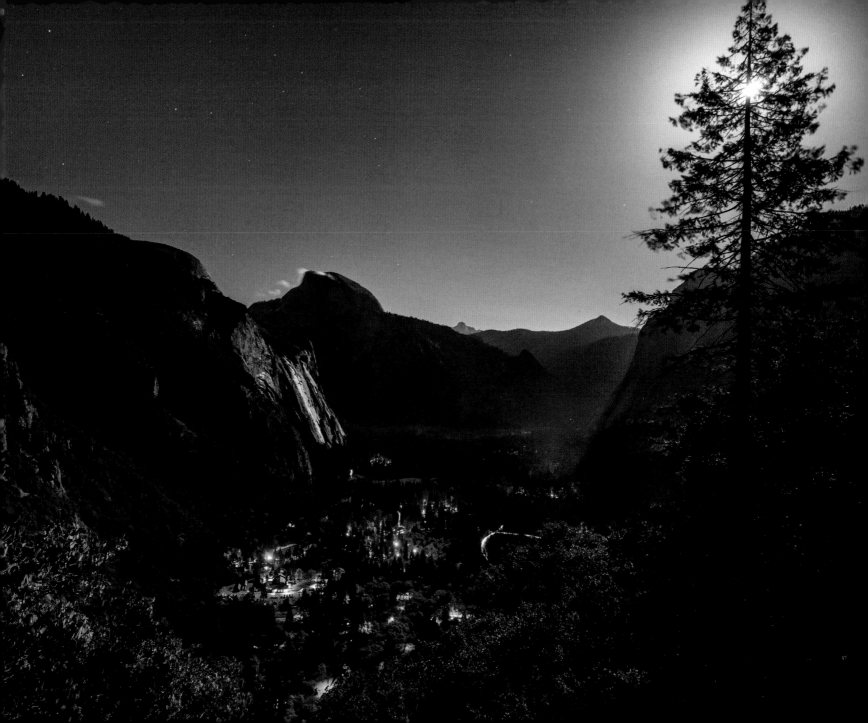

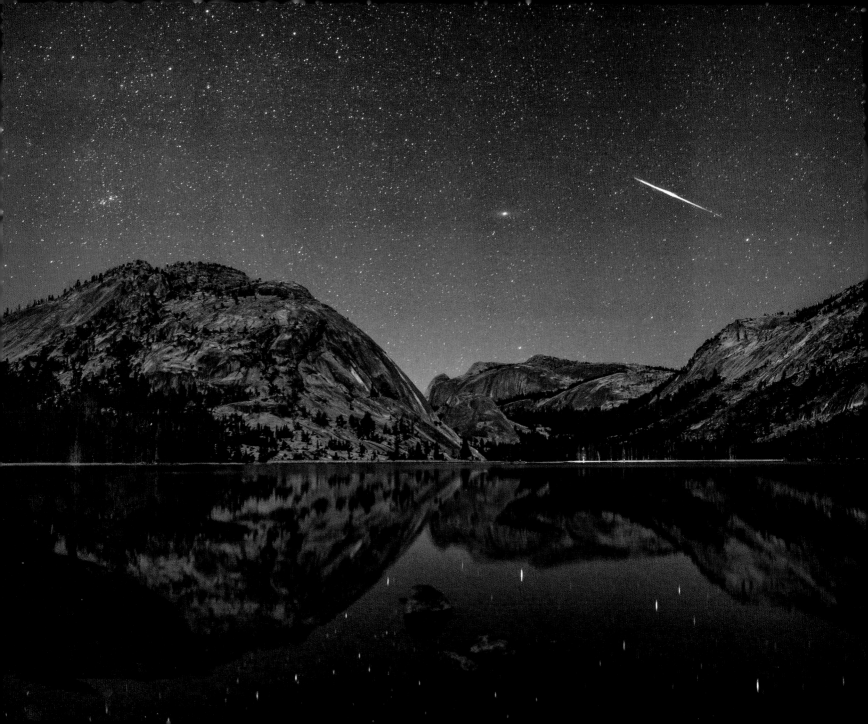

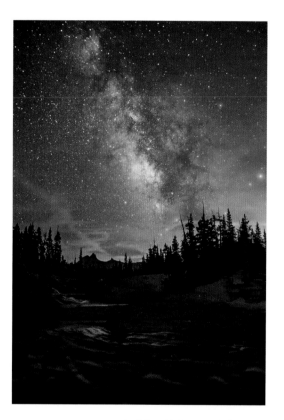

In this mid-August nightscape along the Tuolumne River, the Milky Way rises to the right of distant Unicorn Peak, silhouetted against a southern horizon brightened by wildfire.

On a still night, a meteor darts across the sky over tranquil Tenaya Lake.

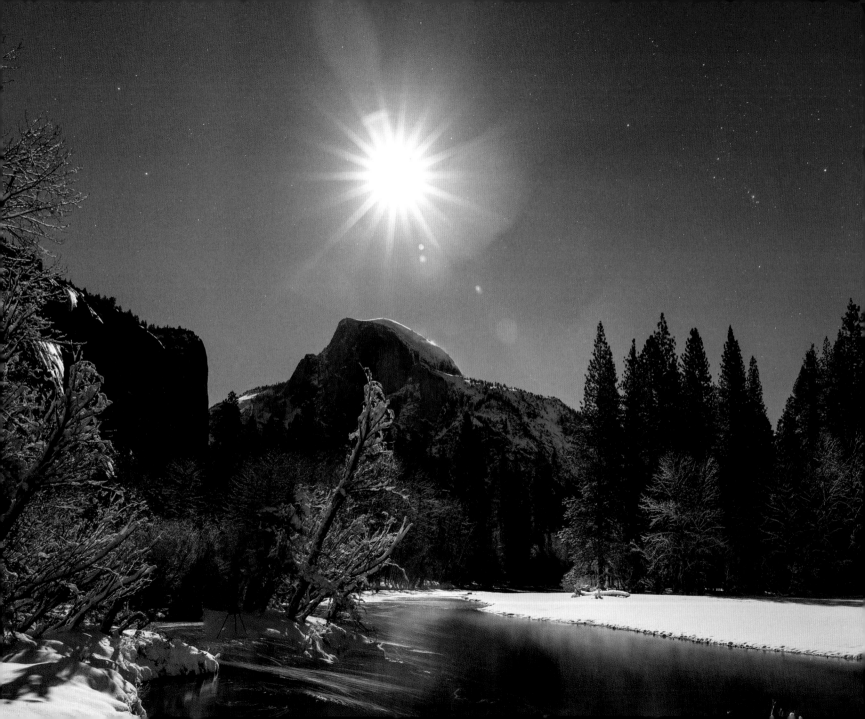

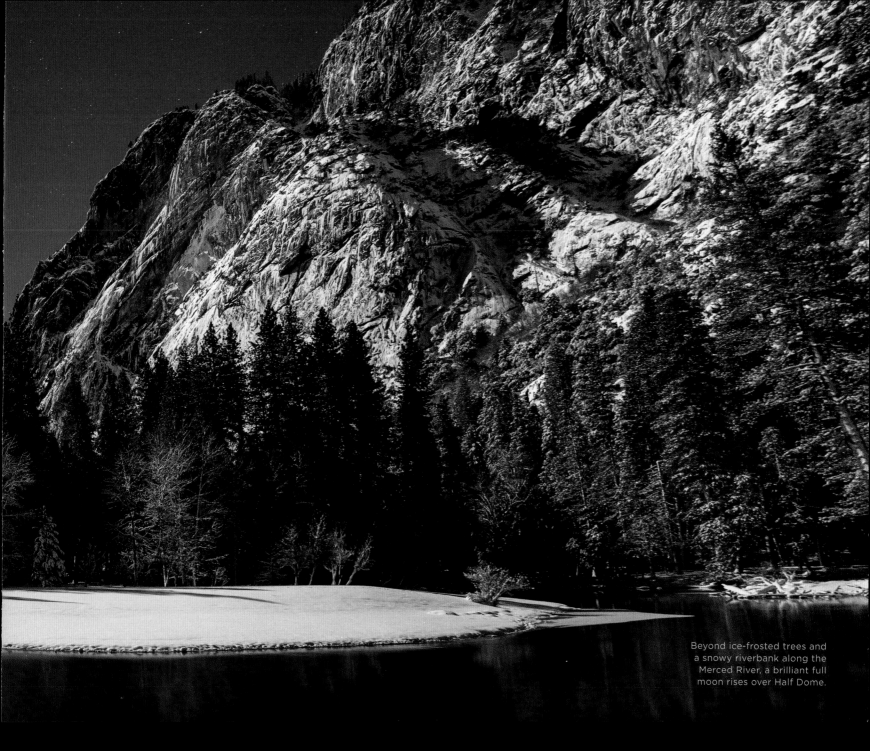

Beyond ice-frosted trees and a snowy riverbank along the Merced River, a brilliant full moon rises over Half Dome.

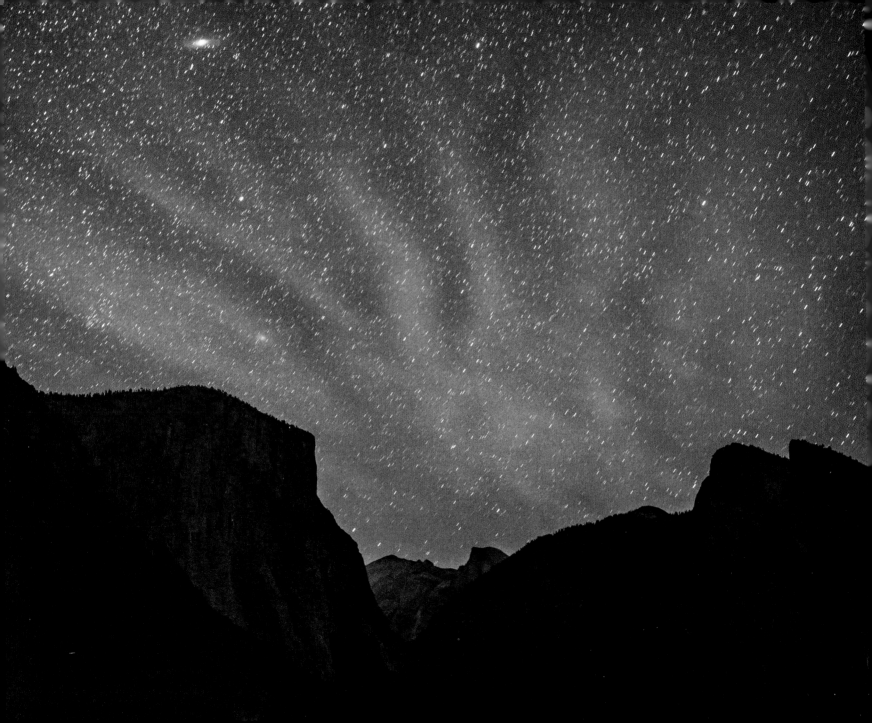

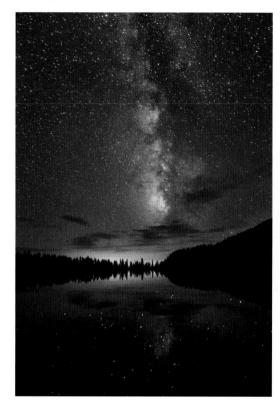 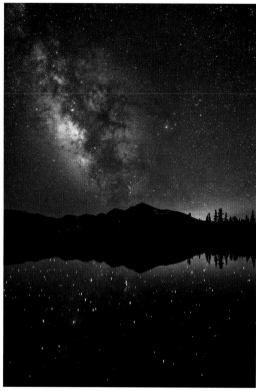

As seen from Tunnel View, the Andromeda Galaxy sits high in the midsummer eastern sky as waves of airglow silhouette El Capitan to the left, Cathedral Rocks to the right, and, in the far distance, Half Dome.

May Lake, at the base of Mount Hoffmann in Yosemite's high country, reflects the Milky Way, along with the glow of light pollution from California's Central Valley.

The Milky Way arcs high above a pond in Dana Meadows, with Kuna Crest in the background.

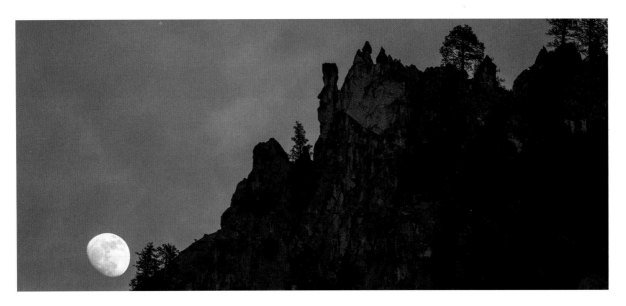

On an early May evening in Yosemite
Valley, a waxing gibbous moon rises
alongside a steep ridge of granite spires.

A series of lights
hung by rock climbers
gleams like a string
of pearls along Snake
Dike, a technical
climbing route up Half
Dome's South Face.

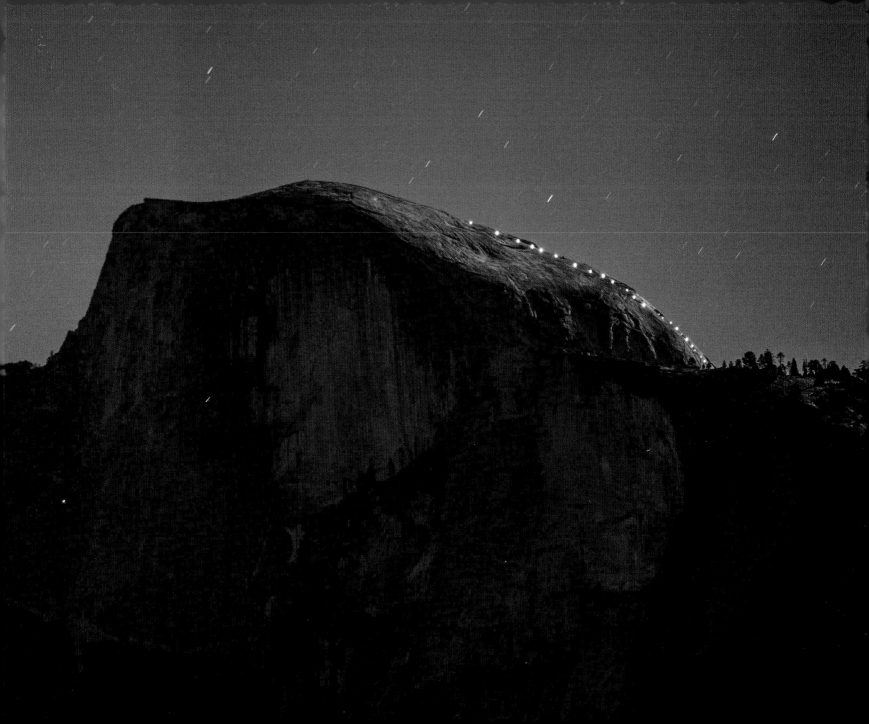

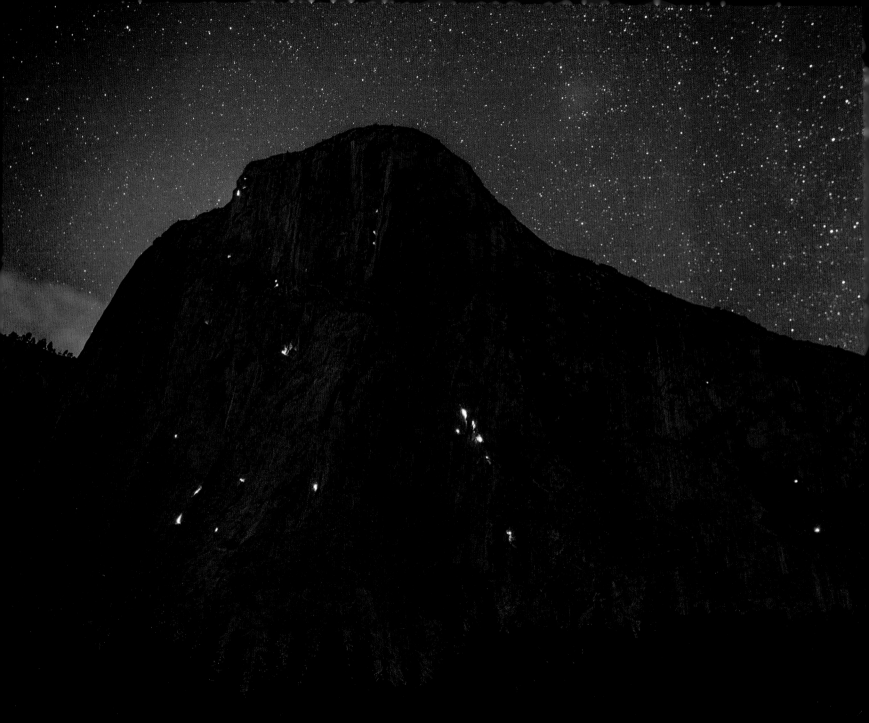

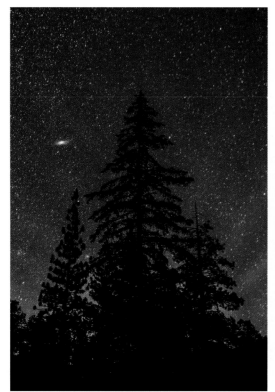

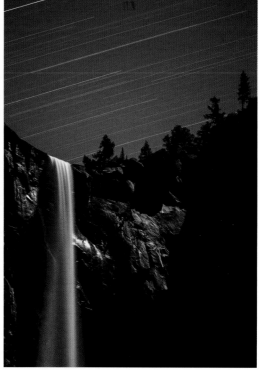

Conifers in Yosemite Valley are backlit by greenish airglow as the Andromeda Galaxy appears to float serenely in the distance on a night in mid-July.

In this twenty-five-minute exposure taken on the spring equinox, star trails extend across the sky as Bridalveil Fall captures the light of a waxing gibbous moon.

El Capitan looms over Yosemite Valley, its steep granite walls punctuated with a constellation of lights from climbers' headlamps.

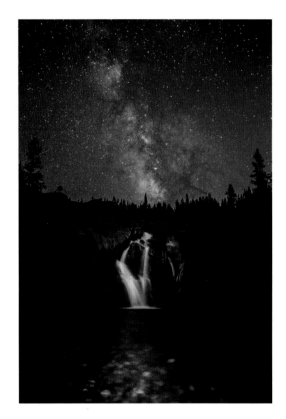

Glen Aulin's White Cascade
takes on a lustrous glow
beneath the expanse of
the Milky Way.

Looking south from
Tuolumne Meadows on a
clear mid-August night, the
Milky Way dwarfs the distant
peaks of the Cathedral
Range. Unicorn Peak and
Cockscomb are on the left,
Cathedral Peak is in the
middle, and Fairview Dome
is in the foreground.

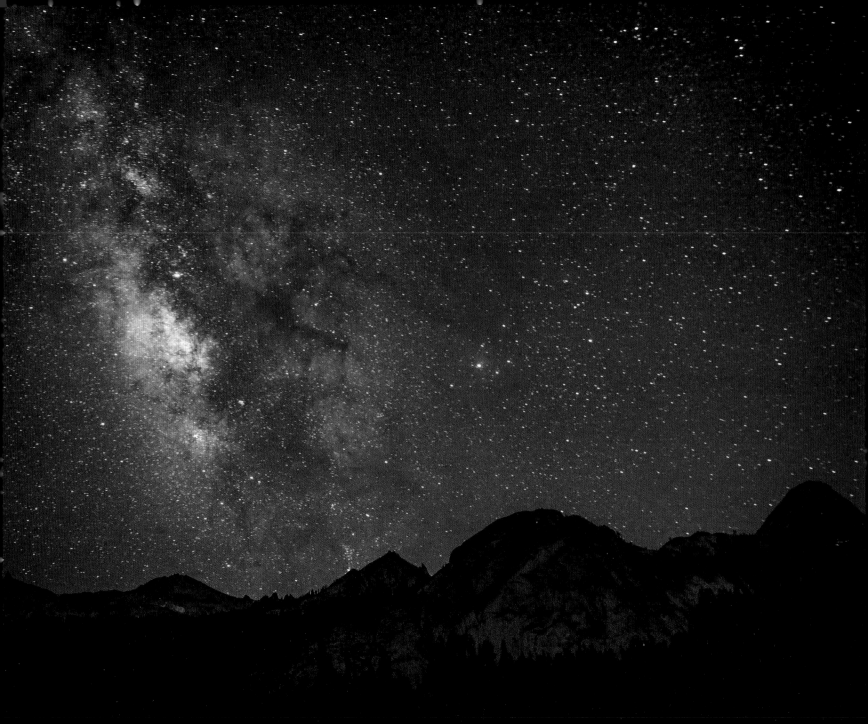

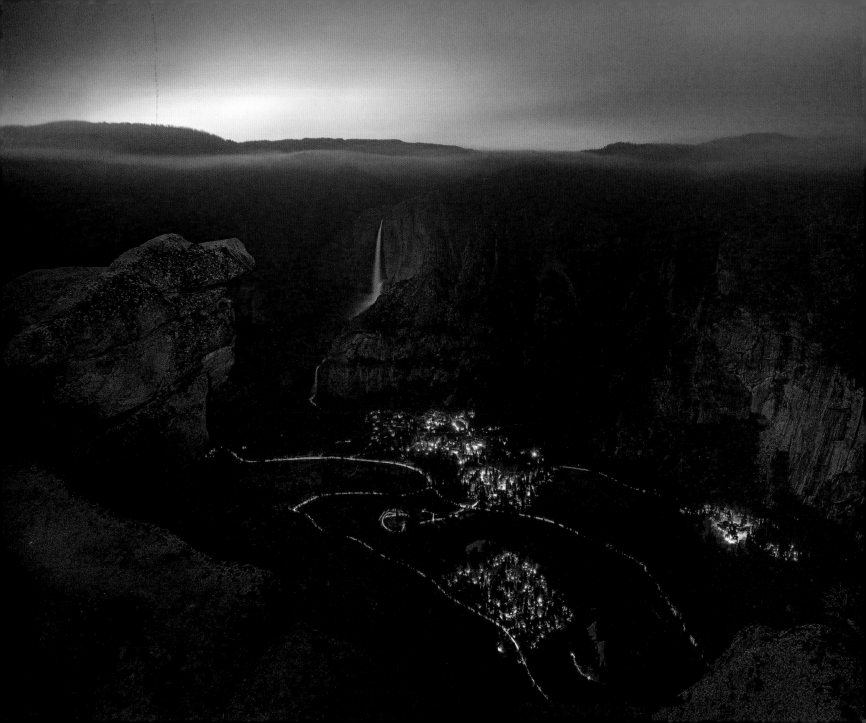

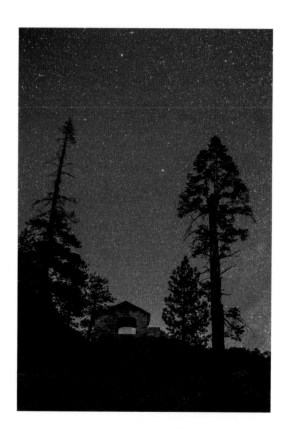

As the summer equinox approaches, the Geology Hut at Glacier Point stands ready to offer visitors a commanding view of Yosemite Valley. Built in 1924, it has been providing educational exhibits for almost a century.

In this five-minute exposure taken from Glacier Point, twilight illuminates thin clouds over the north rim of the Valley, Yosemite Falls tumbles to the Valley floor, and vehicles and lighting etch the Valley's network of roads and buildings.

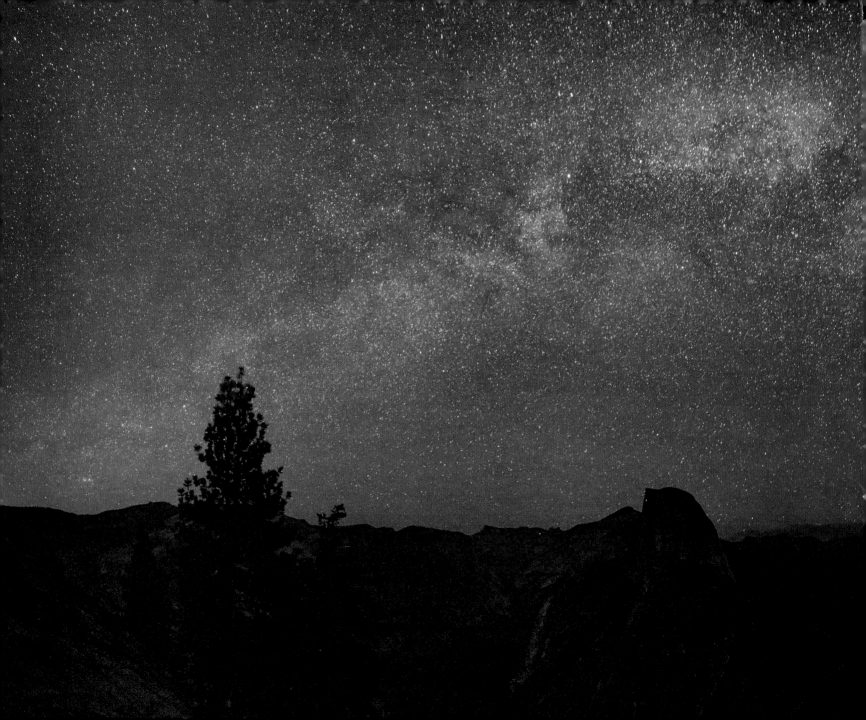

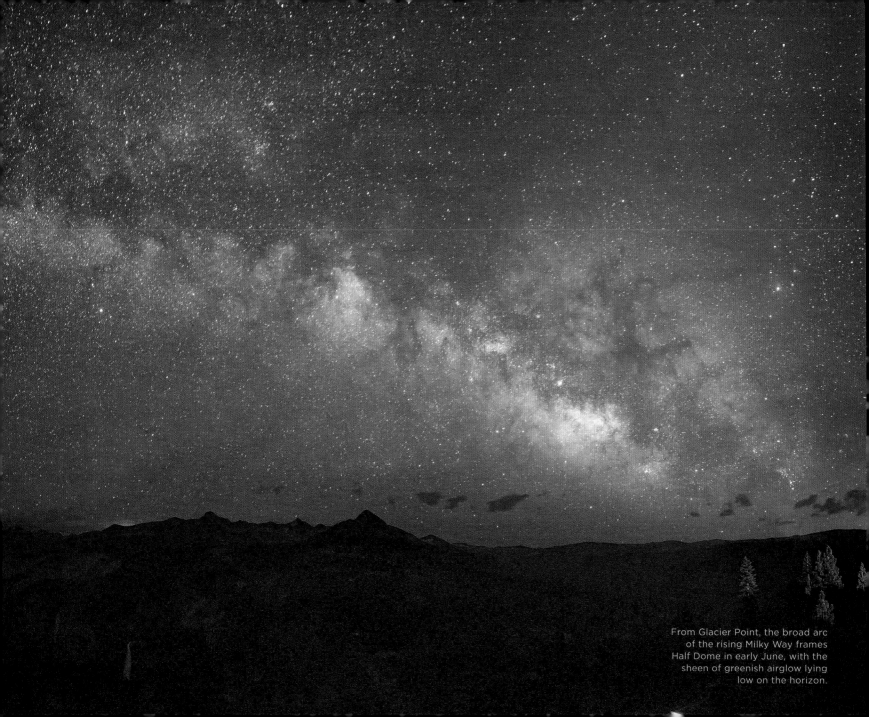

From Glacier Point, the broad arc of the rising Milky Way frames Half Dome in early June, with the sheen of greenish airglow lying low on the horizon.

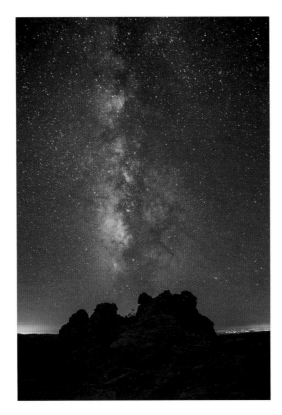

The summit of Mount Hoffmann, at 10,850 feet (3,307 meters), offers commanding views of the night sky and the Milky Way despite light pollution from the Central Valley, which intrudes even here, near the geographic center of the nearly 1,200-square-mile park.

In this shot taken from Mount Watkins in late June, the Milky Way stretches high above Half Dome as light pollution from the Central Valley obscures the night sky along the horizon.

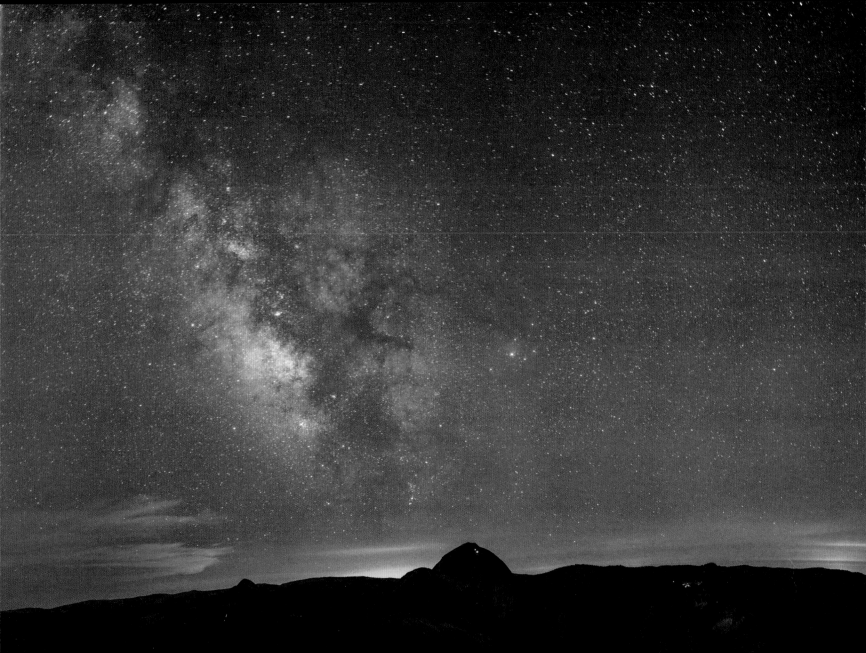

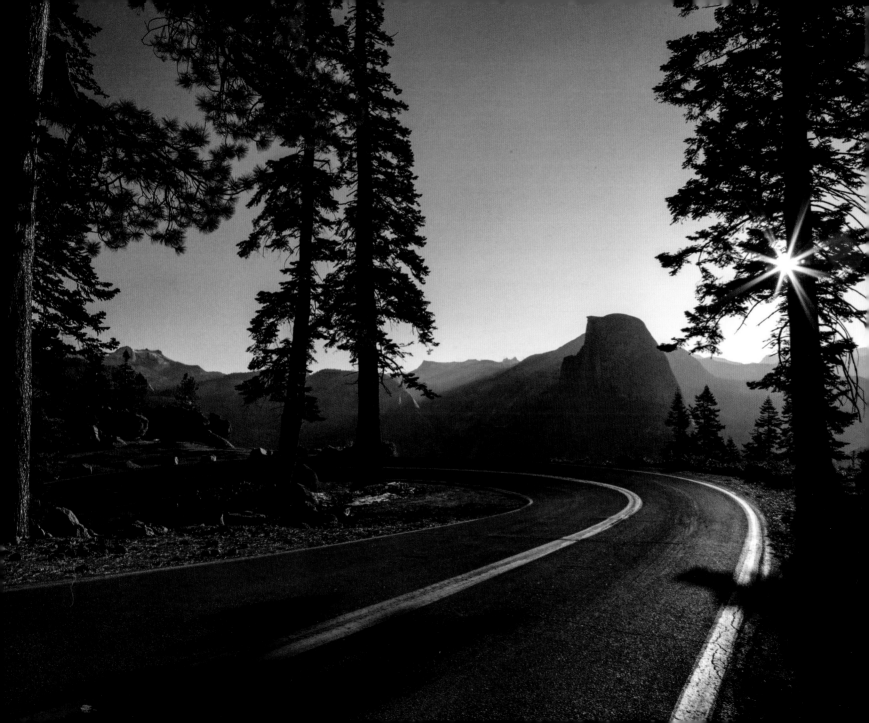

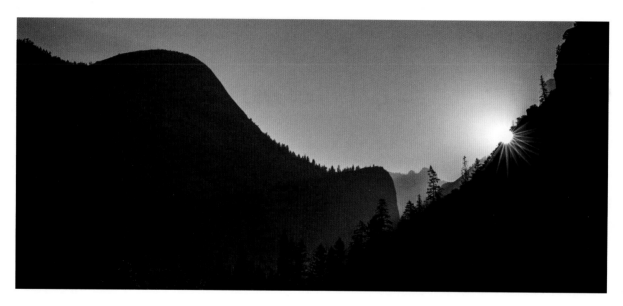

North Dome and Washington Column, left and center, capture the sun's first rays as another day dawns in Yosemite Valley.

Along the road to Glacier Point, Half Dome casts a long shadow as the sun rises on a spring morning.

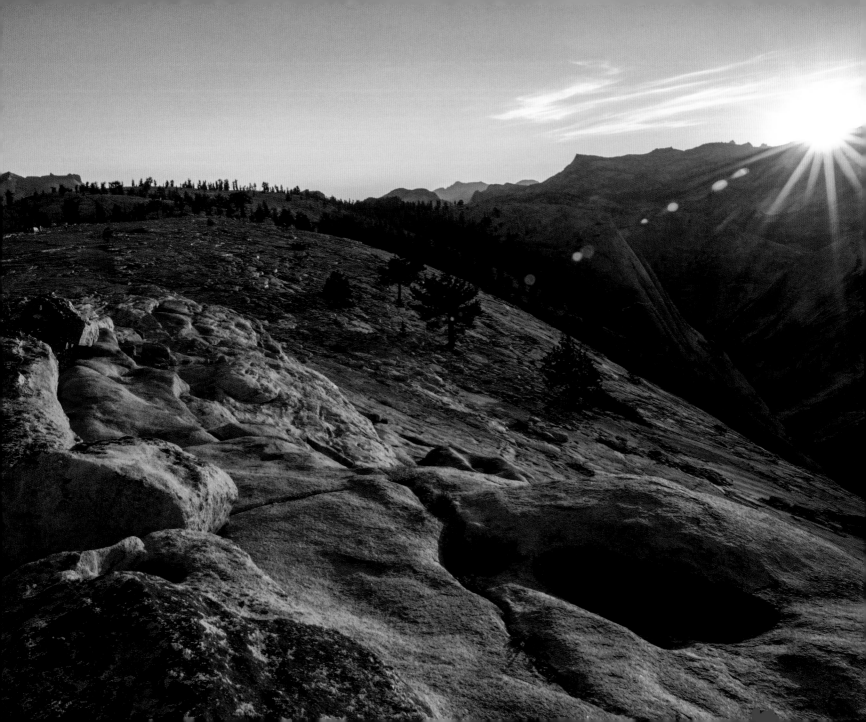

PROTECTING DARK SKIES FOR A CELESTIAL EXPERIENCE

Dark skies are a precious resource. Light pollution not only impacts our ability to enjoy a starry night but also has a devastating effect on insects, migratory animals, and nocturnal creatures. Many animals, including sea turtles and songbirds, depend on the dark in order to see celestial bodies. When light pollution interferes, it can have adverse effects on migration, mating, navigation, and finding food—dramatically altering these crucial ecological rhythms.

There are many ways you can actively protect the night skies from light pollution. Consult darksky.org for comprehensive information on how to select outdoor lighting that doesn't impact the night sky and on how to campaign for a local lighting initiative in your community.

Here are some specific tips for minimizing light pollution at your home or business:
- Put outdoor lights on timers and sensors so they are only on when needed.
- Illuminate only the specific area where light is needed.
- Install lightbulbs that are only as bright as is necessary.
- Minimize blue light emissions, opting instead for warm tones, such as oranges and reds, as these don't illuminate the night sky as much as blue tones do.
- Ensure that outdoor light fixtures are fully shielded and downcast.

Protected lands, such as national parks, remain among the darkest places on earth. Many of these places, including Yosemite, have specific stewardship policies enacted to promote the wilderness value of a natural night sky, relatively untouched by human development. Implementing proactive lighting measures that reduce light pollution in surrounding communities is key to preserving dark skies above parks.

In addition to having ecological value, a dark night sky is part of humanity's cultural heritage. The night sky has been our species' muse for myth, art, and culture for thousands of years. When we stare up at a star-filled sky and allow our minds to wander out toward the farthest reaches of the universe, we are gazing at the same sky that our ancestors looked upon. We all need to do our part to ensure that future generations can connect with this integral aspect of being human.

On one of the longest days of the year, the sun rises early and far to the north, illuminating the broad summit of Mount Watkins in the foreground, as Tenaya Canyon, to the right, remains in shadow.

This book is dedicated to my mom, Anne Leonard.
Her support and encouragement are endless.

Also, thank you to Yosemite's wild creatures for
leaving me alone as I spent many nights in the dark
making these images!

YOSEMITE CONSERVANCY

yosemiteconservancy.org

Yosemite Conservancy's Mission
Yosemite Conservancy inspires people to support
projects and programs that preserve Yosemite
and enrich the visitor experience.

Design by Eric Ball Design

ISBN 978-1-930238-76-3

Printed in China by Toppan Leefung

1 2 3 4 5 6 – 21 20 19 18 17

FSC
www.fsc.org
MIX
Paper from
responsible sources
FSC® C104723

THE CAMERA SEES
WHAT THE EYE CANNOT

Cameras gather light even in the darkest landscape. Using the
three critical elements of photography: shutter speed (exposure
time), aperture value (how much light enters the lens), and ISO
setting (light sensitivity), a camera can record seconds, minutes,
or hours of time in one image.

The human eye is limited in its ability to see in the dark as well as
to pick up color in low-light scenes. The eye also cannot record
light over a span of time the way a camera's sensor can. Digital
cameras, with their electronic sensors, are far more sensitive
than the eye or even film, and can record faint objects with short
exposure times—allowing both the sky and the foreground to
remain in focus. Thus, the night sky will typically be brighter,
more colorful, and more brilliantly filled with visible stars in a
photograph than it appears when we simply use our eyes.

However, there are few things more thrilling than stepping
outside at night to experience the cosmos. We are truly
fortunate when we can appreciate the best of both.